BRUSHING *the* PRESENT

Contemporary Academy Painting from China

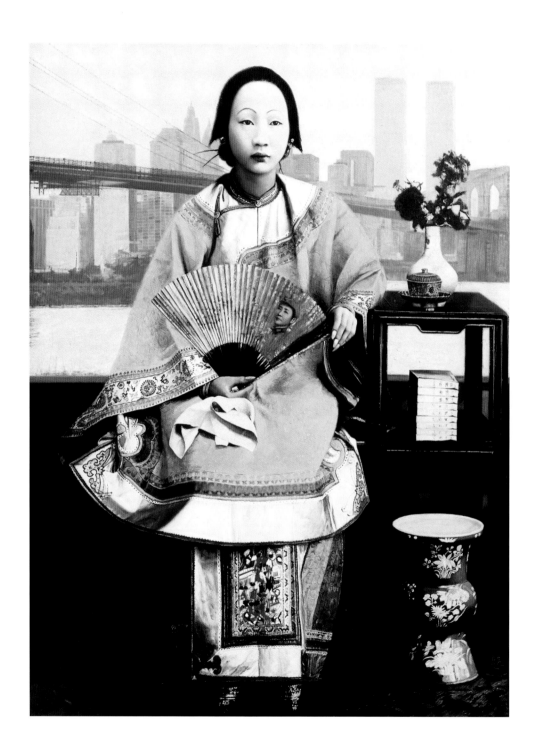

BRUSHING
the PRESENT

Contemporary Academy Painting from China

DORETTA M. MILLER

WITH AN ESSAY BY

JOAN LEBOLD COHEN

THE FRANCES YOUNG TANG

TEACHING MUSEUM AND ART GALLERY

AT SKIDMORE COLLEGE

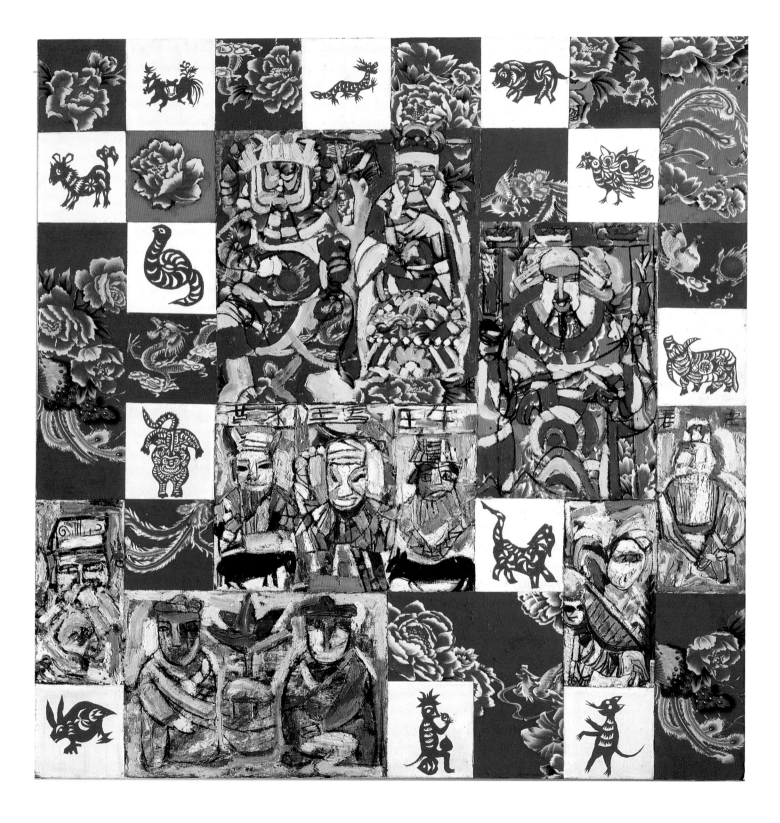

CHEN YINGJUN • CHEN YUPU

DU CHUNSHENG • GAO ZHONGHUA

GU LIMING • HAN CHANGLI • HAO HAIBO

KONG FANTAO • LI CHUNXIA

LI GUANGPING • LIU CHANGSHENG

LIU LEI • MAO LIN • SHEN LING

SHI RONGQIANG • WANG CHUNYAN • WEI RONG

XU ZHENG • YANG DAWEI

YAO MING • YAO XIANING • YAO YONG

YUE DONG • ZHANG HONGBO • ZHANG PING

ZHANG YANG • ZOU GUANPING

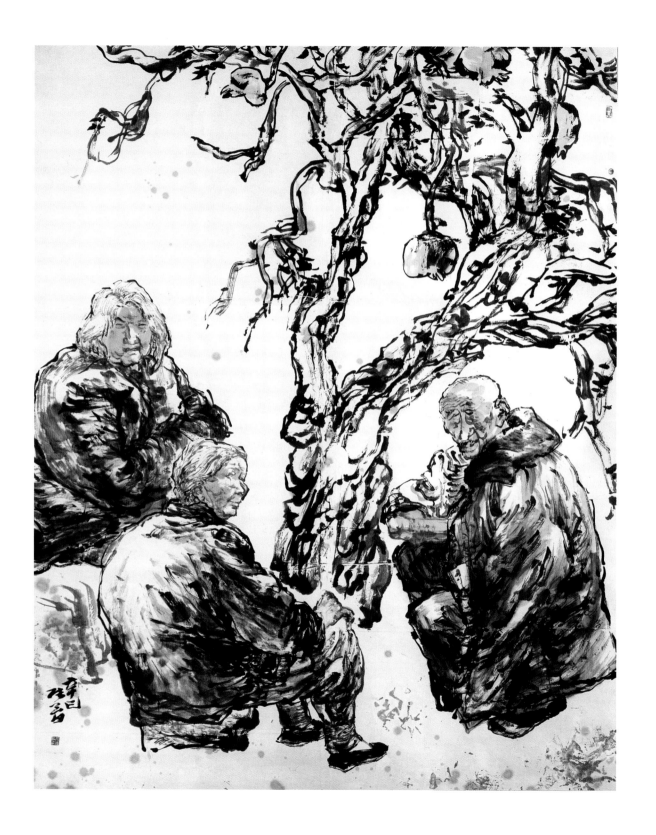

BRUSHING

the Present

DORETTA M. MILLER

Since the end of the Cultural Revolution official policies toward cultural expression in the People's Republic of China have permitted greater artistic freedom and a growing tolerance for Western artistic perspectives. Within the past several years, a burgeoning domestic market and growing number of privately owned galleries that reach audiences outside of China through the internet have developed in urban centers such as Beijing and Shanghai. The new education system has revitalized and expanded art education at universities and academies of fine arts, producing a growing number of academically trained artists who are skilled in traditional Chinese techniques and have also explored contemporary Western art. The university art departments and art academies are important institutional settings where the fine arts are produced and different artistic perspectives and traditions are considered and negotiated. While some artists are

challenged to reconcile the traditional with the new to create images that represent contemporary China, others ignore tradition to create images that appeal to themselves or various audiences. Works in this exhibition where chosen to illustrate how some Chinese painters are responding to these rapid changes. While some contemporary Chinese artists have become internationally known and maintain studios outside of China, the painters in this exhibition are affiliated with Chinese academic institutions and routinely exhibit in state-sponsored venues. This group represents an alternative view to Western audiences with regard to the degree of artistic acceptance and cultural change taking place in China today.

A number of themes emerge from the selected artworks. Regardless of artistic style or choice of technique, these themes include: artists' responses to globalization; portraits, models, and still-life as subjects of the academy painter; the artists' affinities to the Chinese landscape; revitalizing traditional subjects; academic artists choosing folk art and legends as subjects; and, traditional and new expressions of Buddhism.

PREVIOUS SPREAD
Zhang Hongbo
Winter Pomegranates, 2001
Ink and watercolor on paper
66 x 54 1/4 inches

Artists who choose to live the academic life share a commitment to teaching the next generation of artists and use their talents to perpetuate, articulate, and keep vital a visual culture that is distinctive. In periods of social transition and globalization, this is indeed an important role. Faculty artists do not necessarily depend on the sale of paintings to support themselves and their families, and as a consequence, the subjects and themes selected may be influenced less by commercialism and globalization, and more by personal experiences, values, and academic life.

Tasting Tea, Reading Poem, 2001 (front cover) was painted as a happy reminder of the times when friends and artists gather together in Li Chunxia's home. The artist said, "When we sip tea, talk about poetry, and enjoy paintings, we have very good discussions. The painting shows a part of our real life plus the ideal life for intellectuals. Chinese intellectuals and artists dream about the idyllic life the ancient people lived. Literature, poetry, tea, and paintings play an important part in our daily life. So my painting asks the viewer to stop and think about these things." The calligraphy is translated: "Tasting tea and sharing poems is a frequent practice between scholars."

The long tradition of Chinese artists painting for personal amusement and relaxation began with the literati scholars who first turned to painting and calligraphy in the Yuan dynasty. The artist Xu Zheng paints *Artist and Farmers*, 2001 (p. 8) as a reminder of a walk into the countryside with another artist. The portrait captures the creative energy of this individual in contrast to the calm demeanor of the farmers. Xu Zheng explains that he

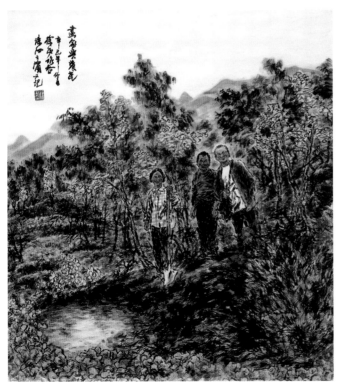

9

sketches on location and finishes the brush and ink paintings in his studio.

During the sixteenth century, traders and missionaries from the West brought to China works of art introducing Western methods of rendering light. In Western-style painting the tone of a color is determined by the amount of light that illuminates a particular area of the painting and unlit areas remain shaded and dark. Traditional Chinese painters found it difficult to accept this approach as it gave the subject an inauspicious aura. The intriguing self-portrait by Han Changli entitled *Dazzling Light*, 1998 (p. 10) is a painting about light. The artist explained that he wanted to use the color yellow to paint the light because this is the way children think of light. Black ink wash covers the areas not in light.

Chen Yingjun frequently sketches students during his classes and then uses the sketches as the basis for large ink paintings. In *Different Poses of Students*, 2001 (p. 12) the artist glues together two separate paintings to make one image. Chen Yingjun adds objects to the composition for balance including a painting of a nude in the lower corner, a pot with a bamboo plant, and a contemporary reproduction of a blue Ming vase with a landscape scene. The artist explained that he includes calligraphy in his paintings because it reminds people that even though they are modern Chinese they are still influenced by tradition. The calligraphy is translated as: "Elegant bamboo, reverent iris, quietly viewing, seeing meaning in the rhythm of wind."

In the early twentieth century some Chinese artists who studied academic oil painting in prestigious European art academies were placed in important positions in the new fine arts institutions of China. Painting studies of nude models is one of the hallmarks of academy painting in the West, and although

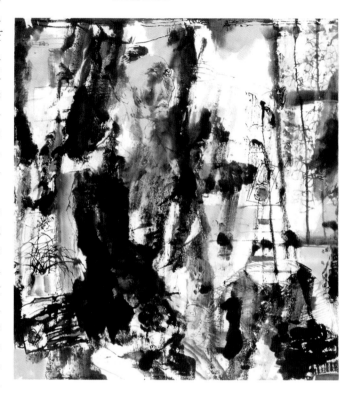

Han Changli
Dazzling Light, 1998
Ink and wash with watercolor
on paper
38 x 35 inches

Kong Fantao
The Female Figure, 2001
Oil on canvas
13 x 9 1/2 inches

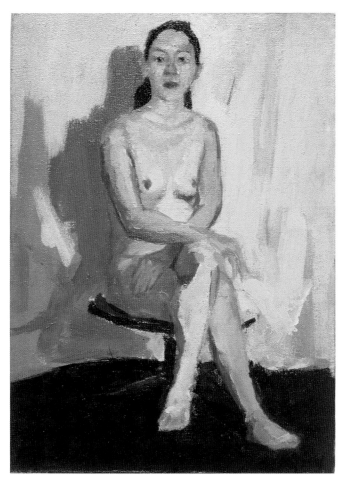

included in the curriculum of some Chinese art schools as early as the 1920s, the practice was controversial. In the 1980s and after the universities and art academies that had been closed during the Cultural Revolution were reopened, opportunities for painting the nude became available. *The Female Figure*, 2001 (p. 11) by the artist Kong Fantao is a good example of Western-style academy painting.

Wang Chunyan placed a floral fabric under a glass bowl filled with brightly colored fruit for her still life painting *A Bowl of Kumquats*, 2000 (p. 37). Wang said she appreciates bright colors because they make her feel warm and happy. Kumquats are native to China, mentioned in Chinese literature of the twelfth century, and are the most resistant of edible citrus to the effects of cold weather.

Zhang Ping, another still life painter, was inspired to apply ground minerals over the watercolors because she considered the results beautiful and compatible with the subject of flowers. The artist selected the chrysanthemum – a flower native to China and a favorite of painters for centuries – as the subject for *Still Life on Table*, 2001 (p. 13). The aesthetic of beauty is very important to Zhang Ping and her arrangements show no bugs or imperfections. Unlike other types of brush and ink and watercolors on paper, Zhang Ping used relatively strong colors and glued the paper to a board to support the additional weight of the minerals.

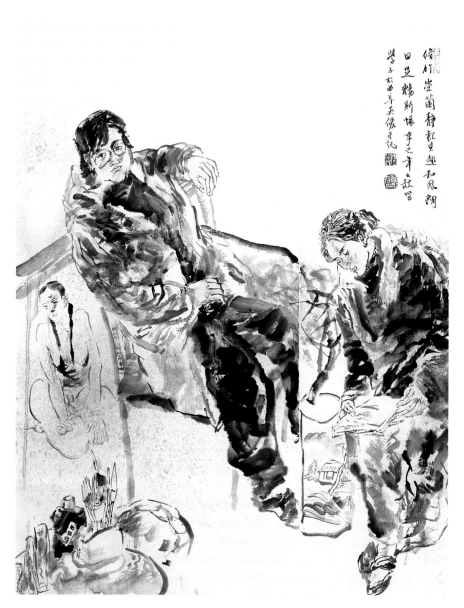

依竹堂蘭種叙見趣和凤朔
曰旦暢斯懷辛巳年之秋寫
學子乙巳平英俊寻記

Chen Yingjun
Different Poses of Students, 2001
Ink and watercolor on paper
102 1/2 x 47 3/4 inches

OPPOSITE
Zhang Ping
Still Life on Table, 2001
Watercolor and ground minerals
on paper on board
29 1/2 x 29 1/2 inches

12

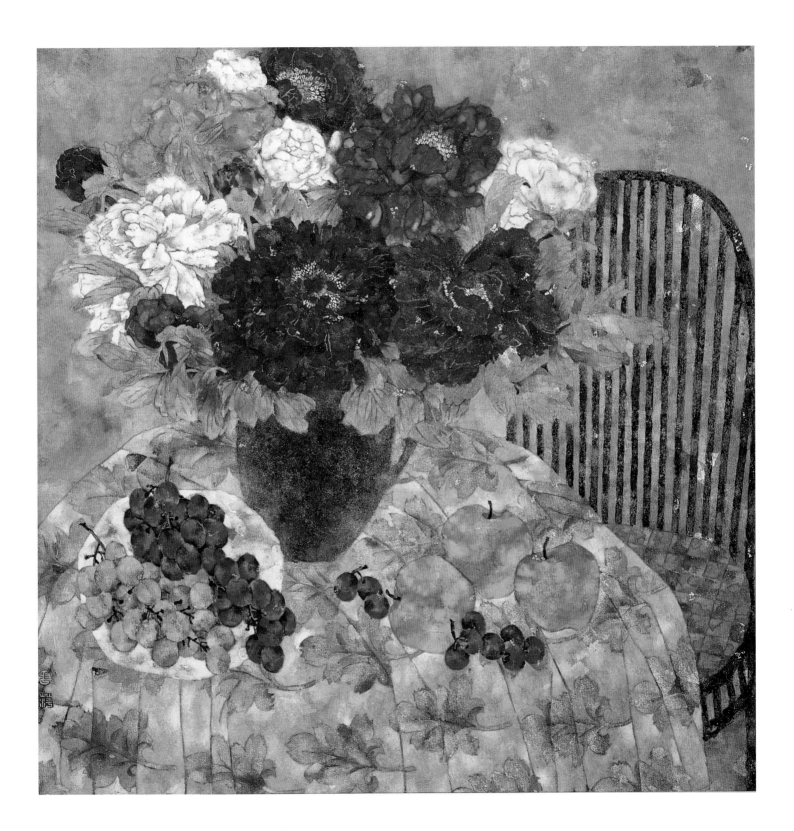

Liu Changsheng
Mountains in Summer, 2001
Ink and watercolor on paper
53 x 26 3/4 inches

Chinese paintings of landscapes have been made for over two thousand years, and numerous complexities of style and experimentation have occurred during the various periods of dynastic change. The study of ancient Chinese masterpieces continues to be part of the academic training of contemporary brush and ink painters. Despite cosmopolitan trends since the beginnings of the twentieth century, the rejection of Western artistic forms by some Chinese artists has been and continues to be strong within the Chinese cultural world. Liu Changsheng's painting *Mountains in Summer,* 2001 (p. 15) follows the traditional conventions of moving perspective for the landscape with colors used sparingly and ink and ink wash given greater prominence.

Some landscape painters supersede traditional norms by introducing stylized versions of ancient subjects and by informing audiences knowledgeable about traditional painting that this is the work of a modern artist. Hao Haibo depicted the traditional subjects of mountains in mist, trees, and a lone scholar or monk in *Clouds Rising from the Mountains,* 2001 (p. 16). However, the artist also stylized the trees and repeated them without variation so that the modern design aesthetic of a flat surface is created. The artist was inspired to add a Yuan dynasty couplet: "The color of trees is woven into a place that is embedded deep into the five layers of clouds. Where is the sound of literature reflected in the trees that invite the holy companion to come across the bridge?"

Artists who choose to combine brush and ink techniques with modern subjects and Western conventions of space do so with the intention of having their paintings clearly understood by Chinese audiences. In the painting *Fishermen on Weishan Lake,* 2001 (p. 43), Xu Zheng applied the conventions of linear perspective and

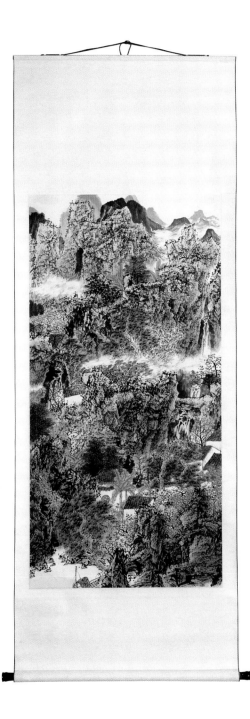

careful observation in the painting of the lake and distant mountains near his hometown. Foreshortening, overlapping shapes, and diminishing amounts of detail help create the realistic illusion of a vast distance within a small sheet of paper - a prime consideration for landscape painters. The broken strokes of the brush and ink are deftly applied and convey the dynamic movement of the water. The artist rejects the traditional norm of citing ancient poetry for this painting and uses the calligraphy instead for his name and the subject of the painting.

In contrast to artists who paint realistic landscapes from observation, some experiment with abstraction to convey intangible aspects of nature. Yao Yong explained that he was inspired to paint landscapes when considering the beautiful patina of ancient Chinese bronzes. "The oxidation of thousands of years has given rich colors to the sacrificial objects, weapons, and tools and endowed them with a sense of mystery. Fascinated and inspired by them, I combined the Chinese traditional painting style with oriental romanticism and mysticism, and created this landscape painting called *Vivid Mountain and Stream* (p. 48) to show a dreamland-like world."

Landscape artists choosing to paint contemporary scenes in oil paint sometime experiment with pictorial spaces that incorporate multiple perspectives. In the painting *A Primary School at the Edge of the Mountains*, 2001 (p. 17), Zhang Yang applies thick paint and expressive brush strokes to capture the physical aspect of the landscape to contrast with the man-made buildings of a local school. This painter experiments with the pictorial space in a creative manner that introduces a multiple perspective that is neither completely Western nor Eastern in style. The scene appears to have lines of sight combining aerial with below-eye-level views and gives a unique convex and concave curvature to the picture plane.

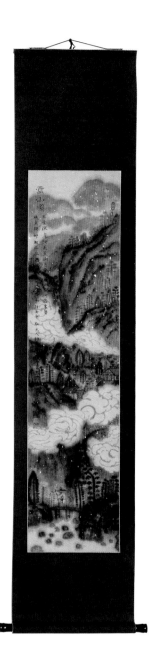

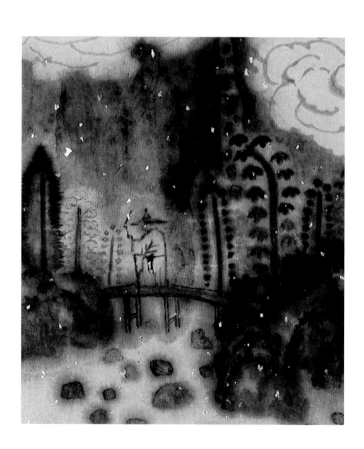

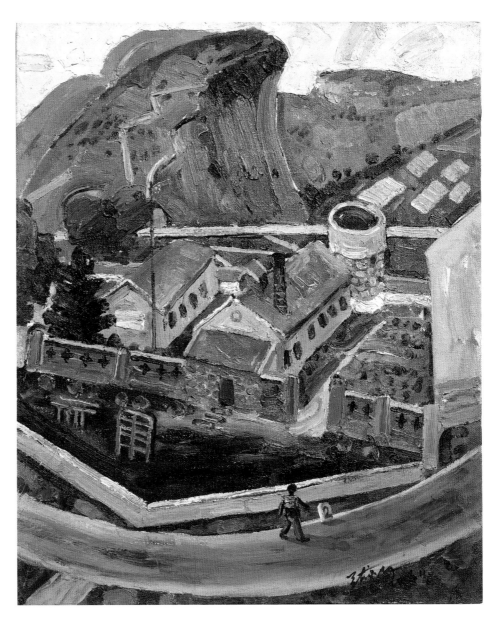

17

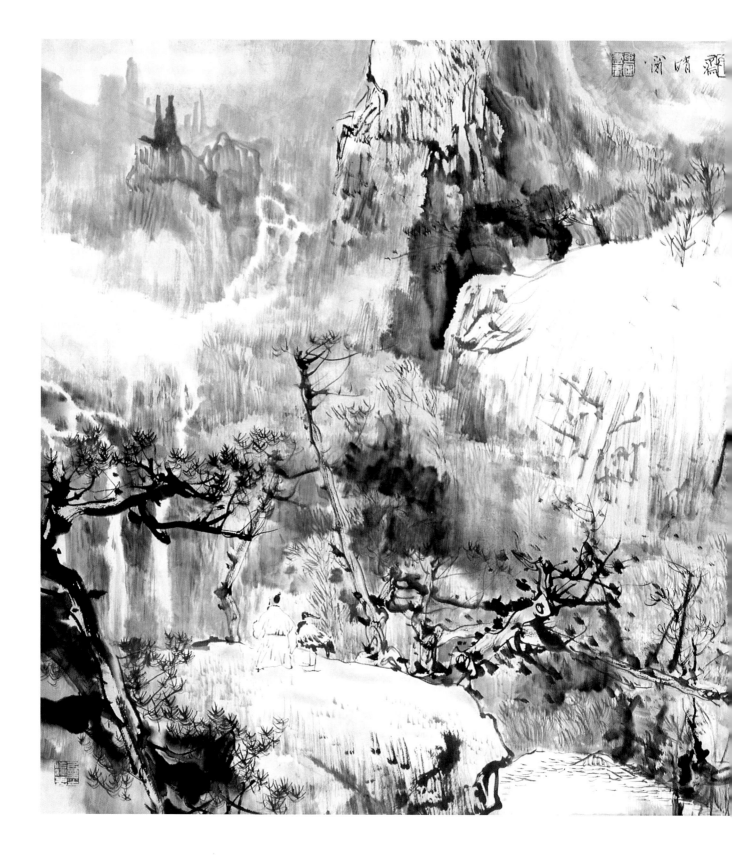

常一處兩樹梢百童長 毫生持廠陳玉圍画於澄門

ARTISTS' RESPONSES TO GLOBALIZATION

Within the past century China has developed from a country of third-world status to global economic partner with the West and entered the new millennium with many socio-economic and cultural opportunities and challenges. Two indications of China's international stature are the support by member nations for Beijing to host the 2008 Summer Olympics and China's recent entry into the World Trade Organization. With an increasing frequency of transnational ideas and the impact of globalization, opportunities exist to practice art for art's sake rather than exclusively to advance the Party agenda. At the same time there is continuity with the ancient cultural traditions through a national art education system that introduces young students at the middle school level to traditional Chinese painting methods and calligraphy that serve as the foundation for all training in the visual arts. China continues to perpetuate a visual tradition of brush painting and at the same time adapts that tradition through the training of its university artists by adapting foreign ideas and transforming them into their own. For Chinese artists trained in both the Western and ancient traditions, the challenge is to create art that remains distinctly Chinese and not just a copy of Western models.

Formal and informal exchange among cultures can lead to change and transitions – as has occurred throughout history. However, the Chinese adapted only to those foreign technologies and ideas consistent with their own values and beliefs. The painting *Always Changing: Evolution Set No. 8, 1998* (p. 21) is an example of a concern for change in which the overlapping planes of two fish are covered by a mound. According to Liu Lei, early life may have begun as fish-like creatures, and since ancient times, the process of

PREVIOUS SPREAD
Chen Yupu
Night Rain in the Mountains,
2001
Ink and wash with
watercolor on paper
40 x 71 inches

Liu Lei
Always Changing: Evolution Set
No. 8, 1998
Oil on canvas
25 1/2 x 32 inches

evolution and change has always been underway. That such change is positive may also be suggested by a play on the phoneme yu that in Chinese can mean both "fish" and "good fortune."

Wei Rong's *A Maid of Honour in Manhattan* (p. 2) was completed in early 2001 when negotiations for China's entry into the World Trade Organization were underway. A Chinese woman in Qing dynasty dress holds a fan with a portrait of Mao Zedong wearing the cap of the People's Liberation Army. The background shows the twin towers of the World Trade Center, an internationally recognized symbol for financial strength and power. This skillfully painted scene integrates images from different time periods and suggests China's progress and transformation into a socialist market economy.

Du Chunsheng's lively brush and ink painting *Rush for Spring Festival*, 2001 (p. 45) shows the smiling faces of well-dressed people crowded together as they begin their journey. Spring Festival is a national holiday that lasts several weeks during which time universities and many businesses close and students and workers visit relatives and friends. After this initial feeling of happiness and excited anticipation, one notices other figures in the crowd whose faces are not smiling and who wear clothing that is old or patched. What might be the socio-economic status of these people?

Shen Ling portrays a contemporary urban couple from Beijing in the painting *Cola*, one of the paintings from *The Love and Lovers Series*, 1998 (p. 50). They are fashionably dressed wearing sunglasses, and carry a Coca-Cola bottle with a label in Chinese and a cell phone – ubiquitous products of a society tied into commercialization and consumerism. The expressive handling of paint and vivid colors suggest a painting style that blends transnational influences.

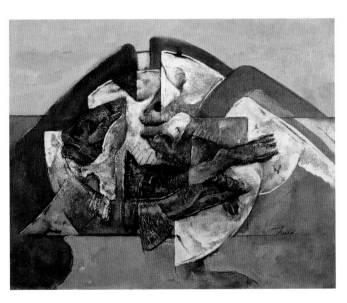

21

Carefully painted details and elaborate furnishings in *Ancient and Beautiful Lady*, 1999 (p. 22) convey a sense of opulence surrounding the courtesan. The calligraphy in the border is obscured by the impressions of seals suggesting the painting is indeed old and was treasured by many owners. The artist indicated that his paintings are commentaries about contemporary life and symbolize his feelings about the world, life, and beauty. Li Guangping is interested in Chinese traditions and visits museums to study objects for his paintings.

For other artists, rural scenes have a special significance, especially those who may have lived among farmers during the Cultural Revolution. These paintings sometimes reflect nostalgia for an innocent and simpler existence in contrast to the harsher realities of contemporary urban life. Chen Yingjun's painting *Past Years in Mao's Period*, 2000 (p. 23) shows a country girl reminiscing about a pleasant memory as she holds a yellow flower in her hand. The calligraphy is translated as "the passing of years is like a song."

In *Winter Pomegranates*, 2001 (p. 6), the artist paints a sympathetic portrait of elderly people from the countryside, sitting under a pomegranate tree with one last fruit at the end of the growing season and the beginning of winter. The bold ink lines used to paint the elders communicate their strength of character from a life of hard work. Zhang Hongbo said he likes to paint farmers as subjects because they are "thirsty for life from a living condition that was not good."

Some artists choose subjects that are widely recognized as belonging to Chinese culture. Yang Dawei said he is interested in the tea arts of ancient China and the traditions only the educated knew and used. "The Chinese people have special feelings about this tradition; there is a special way to taste Chinese tea, not

Li Guanping
Ancient and Beautiful Lady, 1999
Ink and watercolor on paper
with gold
8 x 8 1/2 inches

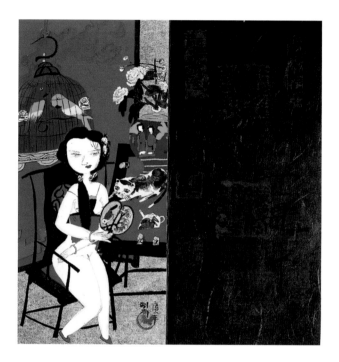

Chen Yingjun
Past Years in Mao's Period, 2000
Ink and watercolor on paper
30 x 13 3/4 inches

like the way Europeans taste tea." The artist painted *Teapot*, 2000 (p. 49) in oil on canvas because he believed the combination of a subject from Chinese culture and Western-style painting creates a stronger image. The earth tones may be a reference to the land as well as the colors of clay used for teapots.

Yao Xianing described the peony as the "national flower of China" because so many consider it their favorite. Yao Xianing also said that Chinese artists have used the peony as a subject for centuries, but when he sketched or photographed the flower the results seemed inadequate. He decided his painting *Red Peony*, 2002 (p. 25) should be painted in a Western style of realism but convey a mysterious quality by concentrating on the shifting light and movement of petals.

Millions of Chinese sports fans read about the lives of basketball superstars including those of the National Basketball Association, and purchase expensive celebrity-endorsed items. *The Boy Who is Playing Basketball*, 2002 (p. 24) painted by Kong Fantao shows a young devotee practicing until sunset. The solitary practice shows determination to improve his skills, which is made all the more poignant to those who might remember their own adolescent dreams of becoming sport stars.

23

Yao Xianing
Red Peony, 2002
Oil on canvas
18 x 21 3/4 inches

OPPOSITE
Kong Fantao
*The Boy Who is Playing
Basketball*, 2002
Oil on canvas
19 3/4 x 24 inches

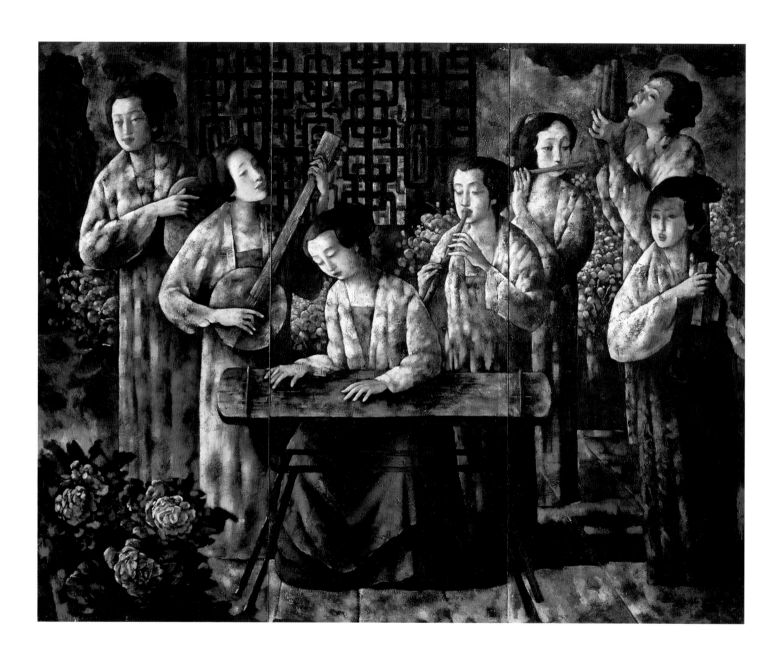

Mao Lin
Harvesting Season, 2000
Ink and watercolor on paper
25 1/2 x 24 inches

OPPOSITE
Yao Ming
The Rhyme of Music in Xixiang,
2000
Oil on canvas
65 x 82 3/4 inches

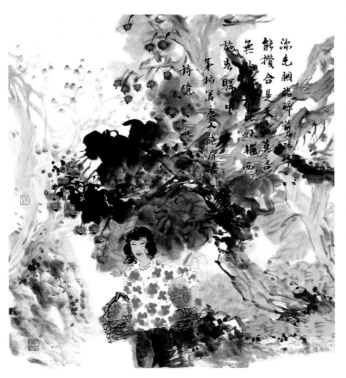

The recent influx of popular images from commercialization and globalization may have an impact on the number of new viewers who will value and appreciate traditional Chinese painting in the future. Some artists are experimenting with ways to revitalize traditional images and themes for contemporary audiences.

Tang dynasty poetry is part of the education of students in China and remains the basis for an artist's training in brush and ink painting. Mao Lin wants to illustrate the content of the ancient poems in scenes that can be recognized by the viewer as modern so that the poetry is relevant. The woman portrayed in *Harvesting Season*, 2000 (p.27) carries a basket of fruit and is dressed in contemporary clothing and hairstyle. The calligraphy is translated: "The painted color (of rouge) scattered in little pieces over the face can bring together the words of the gods in heaven. There is nothing comparable to the beauty of this woman going through the bramble."

Because the stories from the Han and Tang dynasties have changed over the centuries, Yao Ming believes he too can slightly alter the stories in his paintings and does this by changing the colors of a traditional costume, a hairstyle, the number of figures, or choosing a large scale for his oil on canvas paintings. In *The Rhyme of Music in Xixiang*, 2000 (p. 26) seven instruments are shown performing ensemble rather than in traditional groupings of two or three instruments. Only three of the instruments in the painting originated in China during the Han dynasty; the qing, a seven-string instrument; the sun, a reed-like harmonica from Shandong Province; and the xiao, a single stem

27

flute. The other instruments in the scene were introduced to China from other cultures.

Yue Dong specializes in the detailed flower-and-bird paintings that were popular in the imperial courts of the Qing and Ming dynasties. The scene painted in *Richness of Yu Tang*, 1999 (p. 47) includes the types of birds and flowers that embody traditional meanings of wealth and auspiciousness; a gold-leaf background; and the exotic stones found in the gardens of the imperial Summer Palace and Suzhou. Although the norms of the court style of painting are carefully followed, the artist exaggerates the eyes of the birds in a style found in contemporary picture books.

Some brush and ink artists make references to historical figures, reinterpreting them in a modern style preferred by some contemporary audiences. The painting *Picture of Confucius Watching Water*, 2001 (p. 28) portrays the teacher sitting among his students along a riverbank in the tradition of the analects. The faces are exaggerated in a picture book manner that is different from the reverent and refined styles found in traditional images of Confucius. The style of calligraphy used for the names of the artist and Confucius matches the brisk and informal style of the painting. Du Chunsheng who teaches at Qufu Teachers University, located near the culturally important Confucian Temple and Family Cemetery, wants his students to be knowledgeable about the rich heritage of the area and of Confucius.

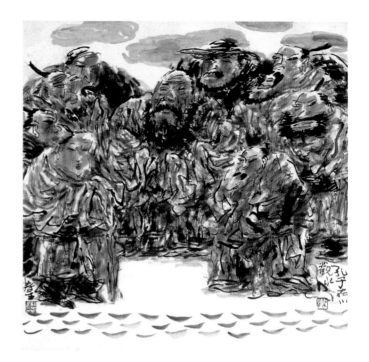

Du Chunsheng
*Picture of Confucius Watching
Water*, 2001
Ink and watercolor on paper
26 3/4 x 26 3/4 inches

Some Chinese artists believe a viable source for a new Chinese art may be found in the subjects of traditional folk arts. In the oil painting *Rich in Every Year*, 1999 (p.4) Gao Zhonghua represents traditional symbols for the Chinese zodiac in the style of the paper-cuts created in rural areas of Shandong Province. A brightly colored fabric popular among farmers is interspersed with the twelve animal signs and portraits of favorite Gate Gods and Guardian Generals. The overall grid suggests the pattern of a quilt from the countryside that is comforting and protective.

The subject of the mixed-media drawing *Qilin Brings the Child to the Family*, 2002 (p. 29) is an auspicious creature from Chinese legends that had the power to punish the evil and repel the wicked. The animal took a quite peculiar form, one that combined the head of a dragon, the tail of a lion, the hooves of an ox, and the horns of a deer with scales all over its body. Gu Liming stated that mainstream Chinese artists have little influence on him because most pay little attention to Chinese traditions and folk arts. The artist believes his drawing style was influenced by the abstract art of Willem De Kooning. Gu combines artistic influences from the East and the West equally to create images that are recognizable to a broader audience.

Shi Rongqiang
The Arahats in the Mountains:
No. 3, 2001
Ink, watercolor, gouache, and
gold leaf on paper
55 x 30 inches

TRADITIONAL AND NEW ARTISTIC EXPRESSIONS
OF BUDDHISM

As Buddhism took hold in China over two thousand years ago, it became a major cultural force that inspired masterpieces of painting. At the start of a new millennium, some Chinese artists are inspired by the philosophic and spiritual tenets of Buddhism and continue within this tradition while other artists use images from Buddhism to express new and secular themes for contemporary audiences.

Chen Yupu's dream-like landscape shows a lone scholar leaving a beautiful mountain scene accompanied by the crane of longevity and nobility. The artist said his belief in Buddhism helps him to communicate a life attitude that is calm and create a light touch to express his feelings of tranquility. The artist wants the viewer to stop, quiet down, and look at the natural order of things - a Daoist philosophy that is also expressed in this painting. When asked whether the artist considers himself a modern painter, Chen Yupu replied, "I'm modern but I can't determine how modern I am. Perhaps I am a modern traditional." The Tang dynasty poem was the inspiration for *Night Rain in the Mountains,* 2001 (p. 18-19) and can be interpreted as follows: "After a night of rain saturating the trees and forming myriads of mountain springs (evoking the feeling of sadness)."

The life of Buddhist monks has been a theme of Chinese paintings for centuries, but in the hands of secular artists, it might be used to express a contemporary desire to live in an environment that is spacious and beautiful. Shi Rongqiang said he yearns for an unconventional, unrestrained existence like what he imagines to be the lifestyle of Buddhist monks. In the humorous

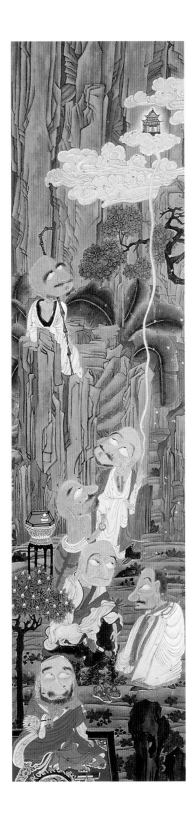

scene portrayed in *The Arahat in the Mountains: No. 1, 2001* (back cover), a very old and enlightened monk is conversing with an insect while leisurely using a back-scratcher. The artist said he is investigating images of traditional Chinese scholar's paintings, folk arts, contemporary picture books, and Western modern art to find the subtle similarities and differences.

While some contemporary Chinese artists are inspired by ancient traditions or reinterpret Buddhist subjects in secular and contemporary ways, many others visit those sites and paint them or, at least, study the photographs of culturally important murals and artifacts found at Chinese archaeological sites such as the Caves of Dunhuang. These artists seem motivated to remind the general population that they should be proud of their ancient heritage and acknowledge the ideas from foreign cultures that have been assimilated and transformed. Zou Guanping said he was interested in preserving the rich cultural heritage of China and in examining the Buddhist images like the flying apsara in *Song of Dunhuang No.4, 2001* (p. 32) as one aspect of traditional Chinese culture. The artist recommends that "modern eyes need to re-read Chinese culture."

Quotes in this essay are taken from interviews conducted in China (June, 2002) by Doretta M. Miller, Professor of Art, Skidmore College, and John L. Reed, Professor Emeritus, Skidmore College.

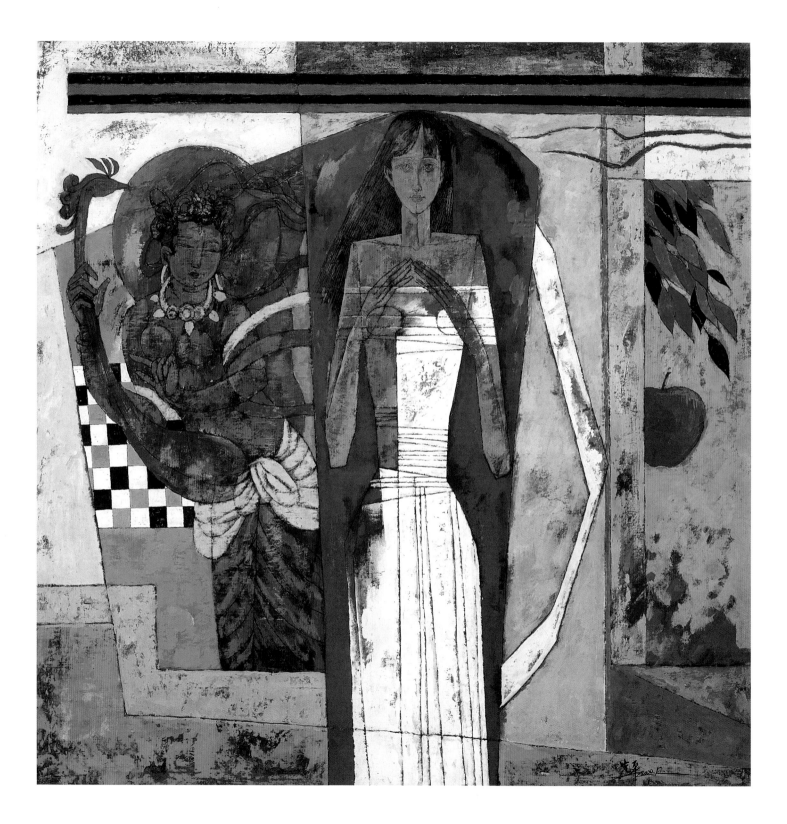

Why do
THE PAINTINGS
look like that?

JOAN LEBOLD COHEN

China has been through so much! No other contemporary civilization can claim 5000 years of continuous culture.[1] This magnificent feat of survival has quite naturally formed the highest mountain of good and evil, beauty and beast that is called Chinese history and tradition. Pity the poor artist who measures himself against the masters of thousands of years of magnificent ink paintings.

It is against this awe-inspiring background that we view current creations, specifically this exhibition of art that is mostly from art faculties in China's provincial universities. Here we see a variety of styles and subjects that are quite different from traditional Chinese painting. The riddle is – why do they look like that?

Chinese artists who are fighting for change have explored new styles for more than a century.[2] Artists were challenged by international art currents new to China and advocated "reform" of Chinese art. Artists also had to respond to govern-

1. Jonathan Spence, *The Search for Modern China.* New York: W.W. Norton, London, 1990. Spence cites 4000 years of record keeping but archaeological evidence shows continuous links with a preliterate society of more than 1000 years earlier. C.K. Chang, *Art, Myth, and Ritual: The Path to Political Authority in Ancient China.* Cambridge MA.: Harvard University Press, 1983.

33

mental demands for change. Oil painting was formally introduced in the early twentieth century, and by mid-century the newly-established Communist regime officially promoted the technique to be painted in styles of academic and socialist realism based on ancient Greek anatomical ideals, Millet's peasants, and Stalin's workers. Yet these new styles and technique would face the perennial xenophobic charge of "copying from the West."

This exhibition features artists who create in styles that are officially permitted by the Propaganda Department of the Chinese Communist Party (CCP). That department sets policy for the Ministry of Culture who guides the Ministry of Education, which oversees the curriculum and teaching in all the art schools in China.[3] Although, technically, artists may use any style as long as it is not deemed subversive and does not defame the Chinese Communist Party, what is taught is formulated by the CCP and the Ministry of Education.[4] This system is quite foreign to artists in the United States, where traditionally the government sets neither art policy nor a national curriculum. The only exception occurs only when the U.S. government funds art projects and considers whether the works of some applicants promises to go beyond the bounds of public tolerance.

Chinese art has a long history of being the conveyance of the moral imperative. In 845 C.E., Chang Yen-yuan wrote in the *Origin of Painting*, "painting promotes culture and strengthens the principles of right conduct."[5] He also notes that Chinese painting is a "symbolic expression" and that it is "meant to serve ceremonial, religious and political purpose or record historical events" and that "at some time it gained, of course, in decorative beauty on walls of palaces, tombs and sanctuaries."[6]

For more than a millennium Chinese artists have prac-

2. Julia K. Andrews &
Kuiyi Shen, *A Century
in Crisis, 1850-1950*.
New York: Guggenheim
Museum, 1998.

3. Joan Lebold Cohen,
*The New Chinese
Painting, 1949-1986*.
New York: Abrams, 1987.
pp.17-23. Interviews
with Chinese artists,
2002-2003.

4. Interviews with
Chinese artists, 2002-3.

5. Osvald Siren, *The
Chinese on the Art of
Painting*, Schocken
Books, USA., 1963. p.7.

ticed ink painting on paper and silk that relies on brush and ink and soft color washes. The subjects range from landscape, birds and flowers, to figure painting. The mastery of many brush-strokes was basic to establishing an artistic vocabulary. Artists learned by studying and imitating nature and, later, by copying old masters whose work inspired them. The variety of brush strokes is amazing and includes tiny sharp lines and dots, massive curving strokes, "axe-cut" strokes that mimic rock formations and "hemp fiber" that is slightly twisting like softly rounded grassy hills. These represent but a few of the vastly inventive traditional brushstrokes and ink forms.[7] Ink washes offer tones and variation and frequently shapes mountain faces and water flow. The Chinese term for landscape means mountain and water in Chinese and these are indeed the basic elements of millennial preoccupation. To indicate distance, aerial perspective was created by hieratic arrangement, with nearest things appearing at the bottom of the composition, middle distance above that, and far distance at the top. Multiple perspective points were used allowing the eye to move easily from one location to another.

After a thousand years of refined development, ink painting appeared to lose much of its energy in the latter part of the Qing dynasty (1644-1911). Interestingly, this mirrored the gradual decline in imperial control of the country, what the Chinese traditionally describe as the ruling elite's loss of the mandate of heaven. In Chinese belief this meant that the current dynasty had lost the right to rule the country according to the "Great Spirit who resides in Heaven" from whom the Emperor's power was said to derive.[8] Popular disaffection was manifested not just in the lost vitality of painting, but in the increasing difficulty of inability of the imperial government to govern fairly,

6. Ibid.

7. Jerome Silbergeld, *Chinese Painting Style.* Seattle: University of Washington Press, 1982.

8. John K. Fairbank, Edwin O. Reischauer, Albert M. Craig, *East Asia, The Modern Transformation.* Boston: Houghton Mifflin Co., 1965. pp.313-407, 613-717. Jonathan Spence, *The Search for Modern China.* pp.137-268.

feed the people and keep the peace in the face of large-scale rebellions, regional warlords and foreign incursions.[9] A principal factor in the demise of the Qing dynasty was its inability to resist the Western imperialist powers. They demanded the right to trade in opium and other commodities, to reside in port cities and to reside in areas on Chinese soil where they could live under their own laws and administration.

China's name for itself, Zhongguo – or the "central realm" – describes how Chinese traditionally had thought of themselves. Being the center of the world expressed the notion of superiority of Chinese civilization and the corollary that people untouched by Chinese civilization were barbarians. During the eighteenth and nineteenth centuries while the industrial revolution was transforming Europe and North America, the Chinese showed little curiosity. Consequently, they were unable to protect themselves in the face of the recently enhanced Western fire power. During the latter half of the nineteenth century some Chinese began to call for reform and "self-strengthening." Reformers argued that if Chinese knew modern science and technology, they could acquire their own modern weapons and resist the imperialists who were trying to dominate China.[10]

During the final years of the Qing dynasty the reformers spurred the imperial government to adopt an edict that called for a complete educational reform.[11] It is significant that an art curriculum of sorts was included within that imperial reform decree of 1902, acknowledging "the advantages of Western drawing techniques for drafting, cartography and illustration."[12] Exact measurement, reformers believed would produce exact rendering of landscape and architecture. Included in this introduction to art was sketching that used 'golden mean' perspective to give the

Wang Chunyan
A Bowl of Kumquats, 2000
Oil on canvas
18 x 21 3/4 inches

9. Ibid.

10. Julia K. Andrews & Kuiyi Shen, *A Century in Crisis.* pp. 1-4.

11. Mayching Margaret Kao, *China's Response to the West in Art: 1898-1937.* PhD. Thesis, Stanford University, 1972. Andrews & Chen, *A Century in Crisis.* Mayching Kao, "Reforms in Education and the Beginning of the Western-Style Painting Movement in China." pp.147–161.

12. Kao, *China's Response to the West in Art.* p. 62.

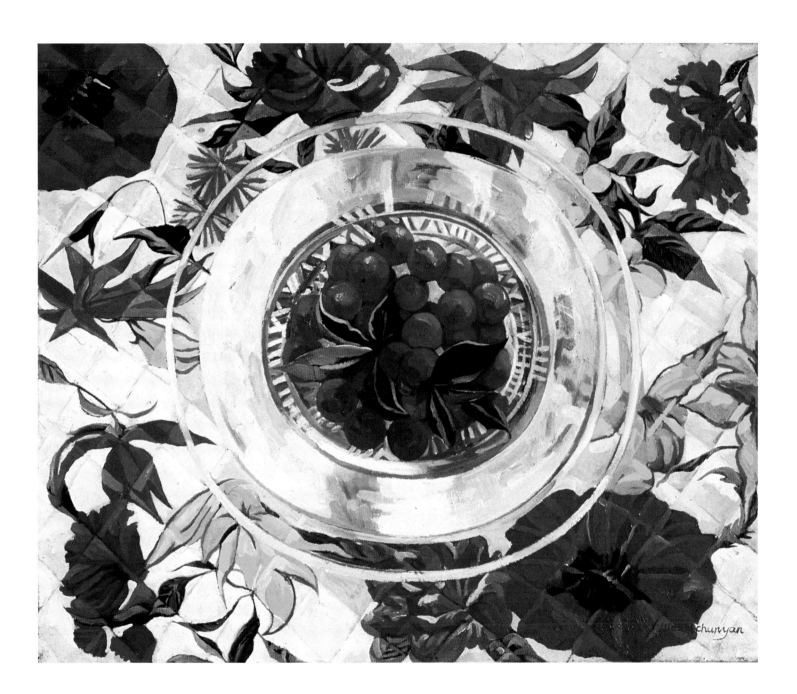

illusion of receding distance on flat surface and chiaroscuro shading in light and shadow, to give the illusion of rounded shapes. This kind of imagery was thought to be realistic and was perceived as scientific and therefore modern. It was different from traditional ink painting, which was more of a landscape in the mind of the artist, who did not seek to record exactly what he could see.

The revolution of 1911 ended the Qing dynasty, which was succeeded by the Republic of China. Soon after, Liu Haisu, a teenage artist in Shanghai, founded the first Western style art school in China. He taught oil painting, deep space perspective and anatomical drawing from models. During the last decades of the nineteenth century and the first two decades of the twentieth century in Japan some Chinese artists had studied 'Western style' painting (oil painting with deep space perspective and chiaroscuro shading) that emphasized an intensely realistic study of nature. The result was a distinctive type of 'naturalism'[13] that represented a revolution in style for China. Some of those Chinese artists returned home to teach, and some Japanese artists also went to China to teach, forming a wave of new art that was perceived to be modern and progressive. This new Chinese art revived academic realism, which had become stale and disfavored by the European avant-garde but took on a new life in transmission.

In 1919, after World War I, the Versailles peace treaty did not return the former German concession of Shandong province to China, but instead awarded it to Japan, one of the victorious Allied Powers. This was done despite American President Woodrow Wilson's avowed ideal of returning colonial people to their nation of origin. On May 4, 1919, outraged

13. Ralph Croizier, *Art and Revolution in Modern China*. Berkeley: University of California, 1988.

38

Chinese students and intellectuals protested vigorously, but in vain. Many reformers abandoned their admiration of Japan, which previously had been a model for China because of its rapid and successful modernization. Thus many Chinese elected to study in Europe rather than Japan, and this exposed art students to a wider range of modernist styles. Shanghai became an artistic outpost for the European avant-garde styles of the 1920s and 1930s such as abstract art and surrealism.[14] However, when the invading Japanese occupied Shanghai in 1937, they put a stop to this experimentation. Many artists joined the Chinese defenders who fled to western regions beyond Japanese control, and especially to the southwestern, wartime capital of Chongqing or to the northwestern, Communist base in Yan'an. The war cut the artists off from their European intellectual stimulus and philosophical ties as well as materials like oil paint.

The influential Chinese artist, Xu Beihong, had gone to France on a Chinese government scholarship in 1919 and attended the Ecole des Beaux Arts in Paris.[15] There he mastered the Academy's canonical neo-classic oil painting style, a romantic realism appropriate for history painting that employed deep space perspective and modeling. When he returned to China in 1927 he devoted himself to modernizing Chinese art by incorporating those elements into ink painting. To Xu Beihong, who was a powerful advocate with a strong sense of mission, "aesthetic rectification in Chinese art would bring about moral uplifting of the crumbling Chinese society, improve the quality of life and reinstate national dignity."[16] While Xu Beihong became famous for his quickly brushed, ink paintings of dramatically foreshortened, galloping horses, and he also became the premier government art educator.

14. Andrews & Chen, *A Century in Crisis.* pp.146–180.

15. Christina Chu & Liao Jingwen, *The Art of Xu Beihong.* Hong Kong: Urban Council, Hong Kong Museum of Art, 1988. pp.44–61

16. Ibid., p 49.

At the same time that the Chinese were fighting the invading Japanese, a civil war simmered between the rival Republican Nationalist government forces under Chiang Kai-shek and the Chinese Communists. In his famous Talks at the Yan'an Forum on Art and Literature in 1942, at the Communist headquarters in northwestern Shaanxi province, Mao Zedong pronounced his vision of where art fit into new China. Art should serve the revolution, he said: "There is no art for art's sake, art that stands above classes, art that is detached from or independent of politics...as Lenin said, cog and wheels in the whole revolutionary machine."[17]

Many of the artists of the Republican era made the transition to the Communist regime after Mao's nationwide victory in 1949. During the Republican period Xu Beihong, for example had created several paintings that the new Communist artistic establishment subsequently claimed as the models for Chinese Socialist Realism. Those large, historical-type paintings featured peasants working the land-giant heroes of new China, capable of moving mountains. Although Xu Beihong had worked for the Nationalist government, he did not follow the government of Chiang Kaishek to Taiwan in 1949, but like many idealistic Chinese stayed on the mainland to serve in new China. His appointment as head of the Beijing Art College simply continued. However, he, like other art figures from the "old society," were sent to the countryside to undergo "reeducation." Following Mao's prescription, they had to live and work with the peasants in primitive conditions as well as study the works of Marx, Engels, Lenin, Stalin and Mao. Xu, the passionate art educator suffered a stroke in 1951 and died in 1953 just as the People's Republic was establishing socialist realism as the official

17. Mao Tse-Tung (Mao Zedong), Selected works, Vol III "Talks at the Yenan Forum on Literature and Art" (May 1942), Selected works, Vol III, p. 86.

art style of new China. Ironically, the Soviet models furnished more of the new artistic canon than Xu Beihong's paintings. However, for nationalistic reasons, it was important for Chinese historians to identify a Chinese source of the style.

For almost 30 years, until the death of Mao Zedong in 1976, the politically conscious nation builders of new China guided the creation of art. Following Chairman Mao's admonitions, they continued to seek an appropriately revolutionary form for Chinese Communist art, which was to be art for workers, peasants and soldiers. No members of the former bourgeois-educated elite could understand the peasants without sharing their lives and feeling dung between their toes. Like Xu Beihong, virtually all pre-revolutionary artists were required to spend extended periods in the countryside. Artists were instructed to paint workers and peasants as their subjects as well as record the heroes and martyrs of the revolution. They should also depict the remarkable achievements of the new society such as dams, bridges, factories and other signs of progress. Appropriate styles in which to paint these political messages were prescribed by the Propaganda Department of the CCP.

Paintings were to be completely understandable to the masses. Socialist realism, academic realism and peasant painting were to be the prevailing style. Belatedly in 1957, brushed ink painting was allowed, but it was fundamentally transformed by realism and patriotic subject matter. Impressionism, post-impressionism and all the avant garde 'isms' of the twentieth century were forbidden until Mao's death in 1976 because they had been painted by "bohemians," who were deemed to be unacceptable Socialist models by the CCP. Artistic production was closely monitored to insure the work glorified the revolution

and contained no criticism. Enforcement was driven by the political winds of the moment, sometimes lax, sometimes intense.[18]

Chairman Mao's death ended the Cultural Revolution that had begun a decade earlier. The Cultural Revolution was the last and most horrendous of Mao's official campaigns to destroy the influence of China's community leaders, artists, scientists, intellectuals, and bureaucrats. The artists were among the favorite targets. Humiliated and abused in stadium-sized struggle sessions, where they were forced to stand, bent over in the airplane position, for hours on stage, while criticized and beaten up. They were accused of being "counter revolutionaries" and "reactionaries." Many were imprisoned, and few escaped the rigors of exile to the countryside for periods of from six months to ten years. By 1979, most artists who survived had returned to their earlier lives, and the Chinese art scene began to change. Gradually, as the old guard retired, the new art leaders were determined to separate art and politics and allow far greater freedom in styles and subjects – so long as it did not dishonor China or the Chinese Communist Party.

18. Julia F. Andrews, *Painters and Politics in the People's Republic of China*, 1949–1979. Berkeley: University of California Press, 1994. Joan Lebold Cohen, *The New Chinese Painting*, 1949–1986.

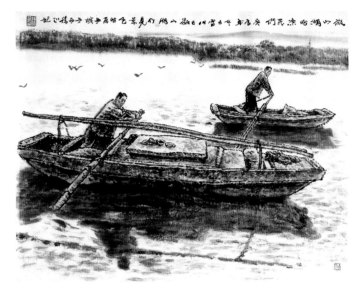

19. Ralph C. Croizier
editor, *China's Cultural
Legacy and Communism*.
Kai Hsieh, "Pan
T'ien-Shou's Art." New
York: Praeger, 1970.
pp. 230-232.

All of this telescoped history is a prelude to the art we see today, especially the art practiced in the government academies, such as in this exhibition. Here we see that ink painting in the traditional mode had truly been transformed during the first thirty years of Communist rule. Echoes of the old landscape style can be detected in the works of Chen Yupu, Liu Changsheng and Hao Haibo displayed here. Yet they would not be mistaken for earlier work. Chen Yupu's *Night Rain in the Mountains* (p. 18-19) draws inspiration from a foremost modernist, Pan Tianshou, (1898-1971) the founding director of the prestigious National Art Academy in Hangzhou. Pan Tianshou had attempted to adapt traditional painting into a larger, more monumental composition by enlarging isolated landscape elements like the rocky mountain hillside.[19] Liu Changsheng's landscape follows the archaistic formula of distance suggested by layers of elements piled up; close on bottom, middle distance in mid scroll and far distance on top. Yet, it has a literalness that draws on a thorough education in realism. Contemporary Chinese artists spend more than half of their art education drawing images from life, and they succeed brilliantly. Closer in spirit to old landscape style, Hao Haibo's landscape has the impish charm of folk art infused into the play of dots and soft washes of the tradition used freely and organized into an ancient scroll format.

Mao Lin and Chen Yingjun paint women of our time, not the fairy nymphs, noble ladies or stately beauties of traditional painting. This is the art of the people, the earthy realism of daily life called for by Mao. Daily life is also featured in other ink scenes by Xu Zheng and in the 'freely brushed strokes' – called xie yi in Chinese – of Mao Lin. The same applies to the contemporary crowds depicted in Du Chunsheng's, *Rush for Spring Festival* (p. 46),

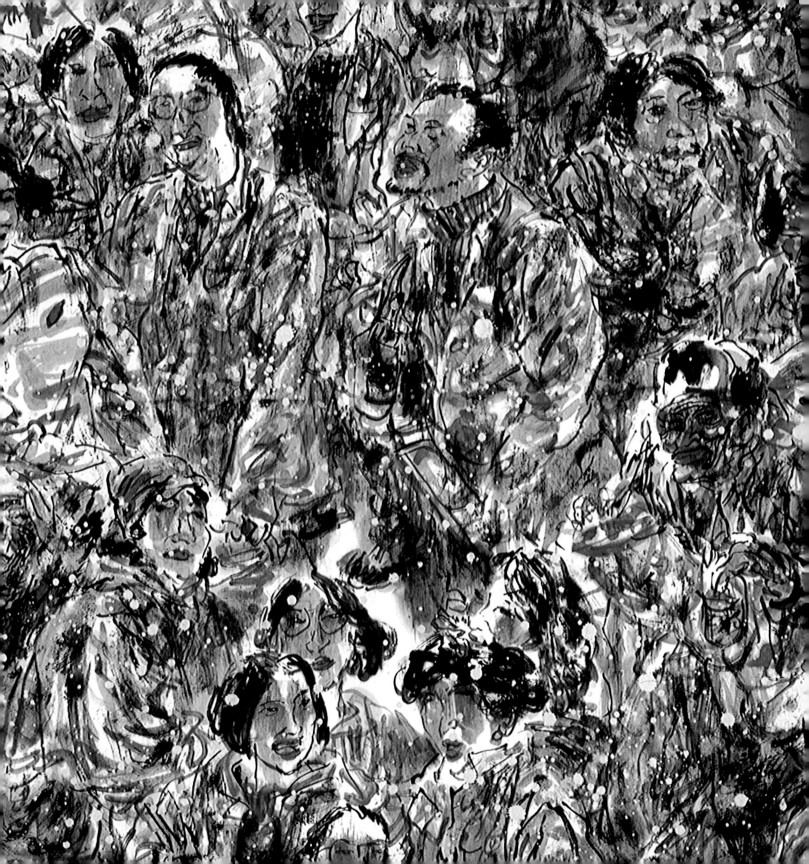

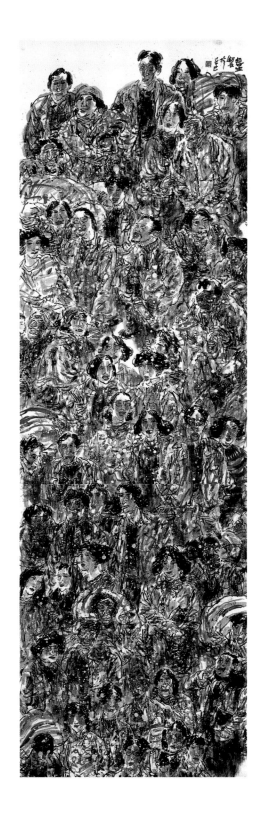

but he has used the traditional spatial formula of piling people one on top of another in a bird's eye view. Du uses a caricature/cartooning style employed by many woodblock printers in the 1930s and 1940s to lampoon the corruption of the Nationalist government and also to resist the Japanese invaders. Caricature was also occasionally used in the Buddhist artistic tradition, portraying sages and masters in an ironic manner. Buddhist, Confucian or Daoist deities are frequently portrayed in similar styles. Zhang Hongbo's ink composition has a bitter edge showing old, bent and huddled peasants near a tree with a single pomegranate. Was it their only promise of hope? Chinese Communist art creators admired Kathe Kollwitz very much for her expressionist creations of the disenfranchised, and her prints served as a model.

Li Chunxia's facile brush style, exhibited in a delicious still life, draws upon the model of the early twentieth century genius, Qi Baishi. In 1949, Qi was honored by the new regime as the grand old man of Chinese painting. Although he continued to wear the maligned feudal costume, a floor length traditional robe and long white beard, he was brought to meet foreign visitors to show that traditional culture was appreciated in new China. Qi had an international reputation and would be asked for by visitors. In the view of Chinese officals, Qi had a favorable class background; he had been born into a humble family and began life as a carpenter. Also important, his presence would stop questions about what has happened to the ink painters? Chinese art planners could not tolerate negative public relations during this sensitive time when they were, in fact, condemning traditional ink painting as feudal and unacceptable in new China. After 1957, traditional ink painting was given a reprieve,[20] although it would never be the same. Training in academic and socialist realism plus

46

Yue Dong
Richness of Yu Tang, 1999
Ink, watercolor, gouache, and gold leaf on paper
47 1/2 x 17 1/2 inches

20. Ibid., Anon. "A New Day for Chinese Painting." pp. 226-228.

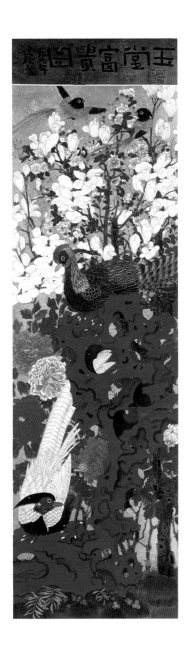

the propaganda subjects required in all art schools and artists' associations would subvert the older style.

The fine watercolor technique used by Zhang Ping can be admired in her still life. Watercolor paper is stiff and resistant to color – so different from Chinese paper, which is very absorbent. Although both watercolors and ink paintings use water-based colors, the technique and result are not the same.

In *Dazzling Light* (p. 10), Han Changli uses ink wash and color freely in an abstract composition. This freedom of style represents a remarkable evolution of Communist Chinese art policy. Abstractions were taboo from 1949-1976. However, when the next generation of art policy makers was installed in the 1980s, one of its prime objectives was to separate art and politics, which meant that styles were not condemned because of the class background of the foreign artist. Yet, even now, abstractions are viewed with suspicion because the art watchers don't know what the painting means.

Gongbi is a traditional decorative ink painting style with precise ink outlines and filled with brilliantly colored bird and flower compositions. A fine example of this honorable, decorative style is Yue Dong's work. Also Shi Rongqiang's caricatured, eccentric monks sit in a landscape invoking gongbi heavy color and gold. Yet, in fact, there is a traditional blue/green landscape style that is more than a thousand years old. Examples may still be seen in the Buddhist cave murals at Dunhuang in the western desert of Gansu province.

Zou Guangping, like so many artists who have gone to Dunhuang since 1949, has been inspired by the murals that provide fresh Chinese subjects, composition and technique. The heavy color is particularly appealing to the artists of new China,

47

OPPOSITE
Yao Yong
Vivid Mountain and Stream
No.2, 2000
Oil on canvas
15 3/4 x 15 3/4 inches

Yang Dawei
Teapot, 2000
Oil on canvas
20 x 23 3/4 inches

21. Jerome Silbergeld,
Chinese Painting Style.
pp. 25-28.

who had for millennia been constrained by Confucian and Daoist injunctions that warned against color because it is too emotional.[21] Zou's composition combines so many disparate elements: the musician comes from the Buddhist host, and the central, elongated, Twiggy-thin beauty is from the runway models of Dior, and the highly colored background has international abstract elements.

In *Ancient and Beautiful Lady* (p. 22), Li Guangping uses heavy color in a traditional album formula, illustrating the beauty on half the page and then some writing about her on the right side.

More familiar to a Western audience are oil paintings such as the academic realist works of Kong Fantao and the still life compositions of Yang Dawei and Wang Chunyan. Zhang Yang painted the requisite patriotic subject – a proud local scene of a school in a dramatic landscape brushed in a charmingly primitive manner. Another oil painter, Gao Zhonghua mines Chinese folk culture, featuring images of paper-cut, folk art, calendric animals, the kitchen god, guardian figures and other mythological beings.

Yao Yong also uses a traditional Chinese reference to the blue/green landscape style as well as the famous old composition by Guoxi with a waterfall that cuts a path straight down the silk. Yao's waterfall echoes that composition as it courses down the canvas-the cascade nourishes the mountain's haunches. Yao's dense, blue/green pigment evokes a verdant landscape, without images of trees or other details. His composition *Vivid Mountain and Stream #2* (p. 48) has 4000-year-old pictographs scratched into the intense green pigment ground.

Yao Xianing also paints with deepest hues of red for her close up view of a peony – a favorite imperial flower. The sensuous

49

composition echoes the work of Georgia O'Keefe in this interchange of east and west. Western artists have been inspired by Asian compositions since they first were seen hundreds of years ago.

Figure painting in oil is broadly represented here in a variety of styles. The adventurous Liu Lei dissects his subject as if at a post-modern, cubist orgy. Gu Liming brushes his figures so freely that he leaves much room for ambiguous interpretation. Yao Ming's *The Rhyme of Music in Xiaxiang* (p. 26) represents the other end of the realist spectrum. This is a composition organized along golden mean perspective using Renaissance models with musician/nymphs whose faces and forms suggest a combination of Botticelli and the pre-Raphaelites. The pigment is brushed in a manner frequently presented by water-based, color paint.

Shen Ling's *Cola: The Love and Lovers Series* (p. 50) is vigorously brushed with the irony of the new cool generation. Cell phone, coke and shades do not bring happiness to this duo. Their smiles are pasty. Are they at sea as the background suggests? Shen's skillful use of neo-expressionism brilliantly conveys the sense of unease.

Wei Rong's *A Maid of Honour in Manhattan*, 2001 (p. 2) is even more meticulously painted than the gongbi style paintings of Yue Dong. The brush strokes are invisible, and the painting looks like it could be printed. She uses a literal photographic realism to feature a classic beauty from a Chinese photographers shop circa 1900, except for the fan she holds with the image of Mao Zedong in the period 1949-1976 and the modern skyline setting including the twin towers. Painted early in 2001 when entry to the World Trade Organization was on the mind of all Chinese and before the towers were downed, the theme appears to be Chinese stages in modernization or is it dislocation? Wei Rong uses subjects

50

Shen Ling
Cola: The Love and Lovers Series, 2002
Oil on canvas
57 1/2 x 44 inches

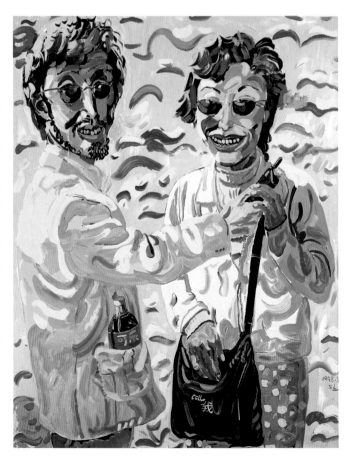

from old and new photographs. Her work, firmly realistic, is puzzling and uneasy, playing on China's fast changing mores in our uncertain times.

Although this exhibition of the styles of the Academy could hardly be described as cutting edge contemporary Chinese art, and many other Chinese artists not represented here pursue conceptual works, photography, video and performance art like their Western counterparts, there is a vast array of styles within this show that certainly would not have been allowed twenty-five years ago. Skidmore's exchange with Qufu Teachers University forms the nucleus of this show, which includes works from other Shandong provincial universities as well. That geography, far from the great cities of Beijing, Shanghai and Guangzhou where the more dynamic artists cluster, permits these provincial schools to linger longer in what were experimental styles for Chinese artists only twenty years ago.

In a universal context, for any artist to achieve media mastery and the modernist goal of originality is impressive. In addition, it is remarkable if the artist creates something that is understood and resonates with the times.

Joan Lebold Cohen is the author of *The New Chinese Painting*,
China Today and Her Ancient Treasures, *Yunan School*, *A Renaissance in Chinese Painting* and many articles. She was a lecturer on Asian Art and Asian Film at Tufts University/School of the Museum of Fine Arts for 22 years.

All works courtesy of the artists
except where noted
Dimensions in inches, height x width x depth

Checklist

Chen Yingjun
ASSOCIATE PROFESSOR,
QUFU TEACHERS UNIVERSITY

Different Poses of Students, 2001
Ink and watercolor on paper
102½ x 47¾

Past Years in Mao's Period, 2000
Ink and watercolor on paper
30 x 13¾

Chen Yupu
PROFESSOR, NANKAI UNIVERSITY

Night Rain in the Mountains, 2001
Ink and wash with watercolor
on paper
40 x 71

Du Chunsheng
ASSOCIATE PROFESSOR,
QUFU TEACHERS UNIVERSITY

*Picture of Confucius Watching
Water*, 2001
Ink and watercolor on paper
26¾ x 26¾

Rush for Spring Festival, 2001
Ink and watercolor on paper
118 x 39¼

Gao Zhonghua
LECTURER, XUZHOU NORMAL
UNIVERSITY

Rich in Every Year, 1999
Oil and fabric on canvas
65 x 65

Gu Liming
ASSOCIATE PROFESSOR, CHINA
ARTS ACADEMY, HANGZHOU

*Qilin Brings the Child to the
Family*, 2002
Tissue, graphite, and pastel on
paper
21½ x 15

Han Changli
ASSOCIATE PROFESSOR, NANKAI
UNIVERSITY

Dazzling Light, 1998
Ink and wash with watercolor on
paper
38 x 35

Hao Haibo
LECTURER, QUFU TEACHERS
UNIVERSITY

*Clouds Rising from the
Mountains*, 2001
Ink and wash with gold on paper
52 x 13

Kong Fantao
LECTURER, QUFU TEACHERS
UNIVERSITY

The Female Figure, 2001
Oil on canvas
13 x 9½

*The Boy Who is Playing
Basketball*, 2002
Oil on canvas
19¾ x 24

Li Chunxia
ASSOCIATE PROFESSOR, NANKAI
UNIVERSITY

Tasting Tea, Reading Poem, 2001
Ink and watercolor on paper
26 x 26

Li Guangping
ASSOCIATE PROFESSOR,
QUFU TEACHERS UNIVERSITY

Ancient and Beautiful Lady, 1999
Ink and watercolor on paper
with gold
9 x 8½

Liu Changsheng
LECTURER, QUFU TEACHERS
UNIVERSITY

Mountains in Summer, 2001
Ink and watercolor on paper
53 x 26¾

Liu Lei
ASSOCIATE PROFESSOR,
QUFU TEACHERS UNIVERSITY

*Always Changing: Evolution Set
No. 8*, 1998
Oil on canvas
25½ x 32

Mao Lin
ASSOCIATE PROFESSOR,
QUFU TEACHERS UNIVERSITY

Harvesting Season, 2000
Ink and watercolor on paper
25½ x 24

Shen Ling
TEACHER, HIGH SCHOOL OF
THE CENTRAL INSTITUTE OF FINE
ARTS, BEIJING

*Cola: The Love and Lovers
Series*, 2002
Oil on canvas
57½ x 44
Courtesy of Ethan Cohen
Fine Arts

Shi Rongqiang
TEACHING ASSISTANT,
QUFU TEACHERS UNIVERSITY

The Arahat in the Mountains:
No. 1, 2001
Ink, watercolor, gouache, and
gold leaf on paper
15 X 15

The Arahats in the Mountains:
No. 3, 2001
Ink, watercolor, gouache, and
gold leaf on paper
55 X 30

Wang Chunyan
LECTURER, QUFU TEACHERS
UNIVERSITY

A Bowl of Kumquats, 2000
Oil on canvas
18 x 21¾

Wei Rong
INDEPENDENT ARTIST, BEIJING

A Maid of Honour in Manhattan,
2001
Oil on canvas
46 x 34
Collection of Howard and
Sharon Rich

Xu Zheng
PROFESSOR AND DEAN OF THE
COLLEGE OF FINE ARTS,
QUFU TEACHERS UNIVERSITY

Fishermen on Weishan Lake, 2001
Ink and watercolor on paper
24¾ x 32¼

Artist and Farmers, 2001
Ink and watercolor on paper
32 x 34¾

Yang Dawei
ASSOCIATE PROFESSOR,
JINING TEACHERS COLLEGE

Teapot, 2000
Oil on canvas
20 x 23¾

Yao Ming
PROFESSOR AND DEAN OF
THE FINE ARTS DEPARTMENT,
QINGDAO VOCATIONAL
AND TECHNICAL COLLEGE

The Rhyme of Music in Xixiang,
2000
Oil on canvas
65 x 82¾

Yao Xianing
ASSOCIATE PROFESSOR,
QUFU TEACHERS UNIVERSITY

Red Peony, 2002
Oil on canvas
18 x 21¾

Yao Yong
ASSOCIATE PROFESSOR, TIANJIN
ACADEMY OF FINE ARTS

Vivid Mountain and Stream No.2,
2000
Oil on canvas
15¾ x 15¾

Vivid Mountain and Stream No.3,
2000
Oil on canvas
15¾ x 15¾

Yue Dong
LECTURER, QUFU TEACHERS
UNIVERSITY

Richness of Yu Tang, 1999
Ink, watercolor, gouache, and
gold leaf on paper
47½ x 17½

Richness of Flower and Bird:
No.1, 2002
Ink, watercolor, gouache, and
gold leaf on paper
10¾ x 9½

Richness of Flower and Bird:
No.2, 2002
Ink, watercolor, gouache, and
gold leaf on paper
10¾ x 9½

Zhang Hongbo
ASSOCIATE PROFESSOR, QUFU
TEACHERS UNIVERSITY

Winter Pomegranates, 2001
Ink and watercolor on paper
66 x 54¼

Zhang Ping
ASSOCIATE PROFESSOR, SHAN-
DONG TEACHERS UNIVERSITY

Still Life on Table, 2001
Watercolor and ground minerals
on paper on board
29½ x 29½

Zhang Yang
PROFESSOR AND VICE DEAN OF
THE COLLEGE OF FINE ARTS,
QUFU TEACHERS UNIVERSITY

A Primary School at the Edge of
the Mountains, 2001
Oil on canvas
25½ x 21½

Zou Guanping
ASSOCIATE PROFESSOR,
SHANDONG ARTS ACADEMY

Song of Dunhuang No.4, 2001
Ink, acrylic, gouache,
and tissue paper on board
39¼ x 39¼

Acknowledgments

The exhibition *Brushing the Present: Contemporary Academy Painting from China* includes thirty-five works by twenty-seven contemporary Chinese artists whose paintings reveal an alternative view of contemporary Chinese art from what is normally seen in North American museums. The artists received their training at various Chinese institutions and are affiliated with universities and art academies in North China. As a group they have received many awards in regional and national exhibitions, have been featured in arts journals, and in some cases are represented by galleries both in China and abroad. To begin the process of selection Xu Zheng and Zhang Yang, Dean and Vice Dean of the College of Fine Arts at Qufu Teachers University, organized an initial list of forty artists and over 150 images of artwork made from 1998 to 2002. Joan Lebold Cohen, an art historian specializing in twentieth-century and contemporary Chinese Art, recommended for consideration six artists who were living in Beijing. The final checklist, chosen by our guest curator, Doretta Miller, includes a wide variety of paintings by men and women ranging in age from their twenties to their fifties.

Many individuals both in China and the United States have made this project possible. Firstly our thanks to Xu Zheng, Dean, and Zhang Yang, Vice Dean, College of Fine Arts, Qufu Teachers University, who worked closely with us on all aspects of this project and served as our liasons to the artists in China. Several people assisted with translation during studio visits and with correspondence including Sun Yan, International Exchange Center, Qufu; Xing Chunlei, International Exchange Center, Qufu; Ji Yunxia, Vice Dean, Foreign Languages, Qufu Teachers University; Wang Chunyan, Lecturer in College of Fine Arts, Qufu Teachers University; Jiang Dongmei, Graduate Student, Qingdao; Wu Ruifeng, Graduate Student, Beijing; Wen Xiuying, Professor of Foreign Languages, Translation Department, Nankai University, Tianjin; Wu Aidong, Lucent Corporation; and Zhou Mei, Doctoral Student, State University of New York at Albany. For their help organizing visits and other logistics while in China, thanks to Kong Xinmiao, Dean, Shandong Teachers University, Jinan; Yao Ming, Dean, Qingdao Vocational and Technical College; Lawrence Wu, Lawrence of Beijing Gallery; Wu Aidong, Lucent Corporation; and Mao Ruiheng, Doctoral student at Nankai University, Tianjin. Special thanks to John L. Reed, Professor Emeritus, Skidmore College, who visited with the artists and assisted with interviews in China; and Sharon and Howard Rich and Ethan Cohen Fine Arts, Inc., for important loans of artwork.

An exhibition that bridges two continents requires many partners, and this project was made possible through the generous support of the E. Rhodes and Leona B. Carpenter Foundation whose grant has made possible two visiting artists and translator from Qufu Teachers University and this beautiful publication. Other important support has come from the Office of the Dean of the Faculty at Skidmore College. Special thanks to Susan Bender, former Associate Dean of the Faculty; Sarah Goodwin, current Associate Dean of the Faculty, and to the Faculty Development Committee who awarded this project a Tang Exhibition Award. Thanks to Stephanie Van Allen, Assistant Director, Foundations and Corporate Relations at Skidmore, for her critical assistance with fundraising.

This catalogue is the work of many, and special thanks are due to Joan Lebold Cohen for her insightful essay. Thanks to graphic designers Barbara Glauber and Beverly Joel of Heavy Meta, and to Arthur Evans for his photography of the artworks. For help with translations and attributions, thanks to Jack Ling, Director, Diversity and Affirmative Action at Skidmore; Mao Chen, Skidmore Associate Professor of Foreign Languages and Literatures; and Margaret Pearson, Skidmore Associate Professor of History.

The Tang staff has contributed greatly to the success of this project, and special thanks are due to Elizabeth Karp, Registrar, who creatively managed the international shipping of the artworks; Chris Kobuskie, Chief Preparator, for his work framing and installing the exhibition; Susi Kerr, Assistant Director for Education and Public Programs, who managed the many lectures, films, and events held in conjunction with this project; and Gretchen Wagner, Curatorial Assistant, who edited texts and assisted with correspondence. Also thanks to staff members: Tyler Auwarter, Helaina Blume, Jill Cohan, Ginger Ertz, Lori Geraghty, Gayle King, and Barbara Schrade; and our installation

crew: Sam Coe, Torrance Fish, Jefferson Nelson, Chris Oliver, Alex Roediger, Pearl Rucker, Thaddeus Smith, and Joe Yetto. Also at Skidmore, thanks to Mary Jo Driscoll, Barbara Melville, and Barry Pritzker for their support.

The partnership between Skidmore College and Qufu Teachers University is a program that has involved many, and without whose work the ongoing exchange and this exhibition would not have been possible. Thanks to exchange faculty from Skidmore College: Tina Levith, Alan and Renate Wheelock, John L. Reed, Pola Baytelman, Sandy Welter, and Murray J. Levith, Director, Skidmore Teach in China Program; exchange faculty from Qufu Teachers University: Yang Xiangxian, Xu Zheng, Zhang Feilong, Jiang Jianye, Fang Mindeng; and translators Liang Meiling and Han Wei.

Many thanks are due to Skidmore Professor of Art, Doretta Miller, whose tenacity kept this project moving forward for two years. She proposed the exhibition, helped raise funds, and has served as its curator and champion every step of the way. The Tang Museum thrives on faculty collaboration, and her work serves as yet another model for the future.

Lastly, we thank the twenty-seven artists featured in this exhibition and catalogue. Several are showing in the United States for the first time, and we are grateful to all of them for entrusting their paintings to us. Their work allows our students and visitors the opportunity to engage with a rarely seen view of contemporary China and to use that view to engage with history, culture, art, and ideas in a new way in our galleries.

Ian Berry
ASSOCIATE DIRECTOR FOR CURATORIAL AFFAIRS/CURATOR
TANG TEACHING MUSEUM, SKIDMORE COLLEGE

A JOURNEY OF 1,000 LI BEGINS WITH A SINGLE STEP.
Attributed to Xunzi ca. 300 BCE - ca. 230 BCE

When put into contemporary context the adage attributed to Xunzi might be rephrased – "a journey of 7262 air miles begins with a single taxi ride." My journey to China began in February 1996 as a participant in Skidmore College's faculty exchange program with Qufu Teachers University and culminated seven years later after a second trip to China to conduct studio visits and artist interviews for this exhibition. Experience as a visiting professor of Western-style oil painting provided the motivation to learn more about my academic counterparts and the artistic interests of those teaching the next generation of Chinese visual artists. An extended network of colleagues and friends in China and the United States provided the base and organizational support without which this exhibition would not have been possible. My thanks also to Skidmore colleagues: Jack Ling, Director, Diversity and Affirmative Action; Adam Yuet Chau, Luce Assistant Professor of Asian Studies; Mao Chen, Director of Asian Regional Studies; and Joan Lebold Cohen, independent art historian, for their important critiques of my exhibition proposal. Thanks to Ian Berry for his invaluable guidance and counsel. Special thanks to John L. Reed for his encouragement and the unwavering support that made it possible for me to give priority to this project during my sabbatical.

Doretta M. Miller
PROFESSOR OF STUDIO ART, SKIDMORE COLLEGE

This catalogue accompanies the exhibition
Brushing the Present:
Contemporary Academy Painting from China
October 16 – December 31, 2003

The Tang Teaching Museum and Art Gallery
Skidmore College
815 North Broadway
Saratoga Springs, New York 12866
T 518 580 8080
F 518 580 5069
www.skidmore.edu/tang

This exhibition and publication are made possible in part through grants
from the E. Rhodes and Leona B. Carpenter Foundation, The Office of the Dean of
the Faculty at Skidmore College, and The Friends of the Tang.

©2003 The Frances Young Tang Teaching Museum and Art Gallery

ISBN 0-9725188-2-7

Library of Congress control number: 2003113224

Edited by Ian Berry
Designed by Barbara Glauber and Beverly Joel / Heavy Meta
Photographs by Arthur Evans
Printed in the United States by John C. Otto Company, Inc.

FRONT COVER
Li Chunxia
Tasting Tea, Reading Poem, 2001
Ink and watercolor on paper
26 x 26 inches

BACK COVER
Shi Rongqiang
The Arahat in the Mountains:
No.1, 2001
Ink, watercolor, gouache,
and gold leaf on paper
15 x 15 inches